David Graham

COLOUR CALLIGRAPHY

Search Press

First published in Great Britain 1991
Search Press Limited,
Wellwood, North Farm Road,
Tunbridge Wells, Kent TN2 3DR

Reprinted 1992, 1993 (twice), 1994.

The Publishers would like to thank The Board of Trinity College Dublin for permission to reproduce folio 291v from the Book of Kells, shown on page 5.

ISBN 0 85532 609 3

Publisher's note

There is reference to sable hair and other animal hair brushes in this book. It is the Publishers' custom to recommend synthetic materials as substitutes for animal products wherever possible. There are now a large number of brushes available made of artificial fibres and they are just as satisfactory as those made of natural fibres.

If you have difficulty in obtaining any of the materials or equipment mentioned in this book, then please write for further information to the publishers: Search Press Ltd., Wellwood, North Farm Road, Tunbridge Wells, Kent TN2 3DR

Composition by Genesis Typesetting, Rochester, Kent
Colour Separation by P & W Graphics Pte Ltd
Printed in Spain by Elkar S. Coop

Contents

Introduction

We may have become so used to black letters on the white printed page that our attitude to calligraphy may tend to conform to similar tonal values. It is time-consuming for a printer to wash down his machine in order to change printing ink, but comparatively easy for calligraphers to wash their nib or quill. The printer has a valid excuse to work in black, but, with the beautiful legacy of colourful manuscripts, I want to encourage you to consider the possibilities of colour.

We have an enormous range of colours and media from which to choose, unlike earlier craftsmen who had to gather their colours from natural sources and manufacture them with the limited chemistry of the time. Yet their understanding and creative use of these materials were highly sophisticated.

The Book of Kells, created early in the eighth century, has been called the most beautiful book in the world. The monks used pigments like white and red lead, verdigris or copper green, orpiment yellow, lapis lazuli, woad blue, kermes red, and plant dyes for pinks and purples. From what may seem to us a minimum of means, the work executed 'seemed to have been done by angels', such is its quality and beauty. Yet some of the pages, like the Gospel stories, are full of humour and everyday detail and, like some of the pigments, earthy.

The portrait page of St John, shown opposite, as a typical page from the Book of Kells, is worthy of closer inspection in relation to some of the themes of this book. Examine the various weights of line, and the variety of decoration and texture held in clearly defined shapes. Colour plays an essential part. The complementary blues and oranges carry the eye around the page, and the yellow shines like gold as it is brought to life by the warm tint of the halo. The whole frames the softer related colours of the figure of St John. Incidentally, the portrait of Christ with arms outstretched has been trimmed away by a less than careful nineteenth century binder.

This century saw the rebirth of formal calligraphy with the genius of Edward Johnston (1872–1944). The emphasis was on the mark and letterform created by the square-cut quill or pen and the letterform's natural beauty and vitality. Graily Hewitt, a colleague of Johnston's, researched approaches to gilding and illumination, and the seeds sown by William Morris (1834–1896) and the Arts and Crafts Movement flourished and developed. From these vital beginnings calligraphy developed and spread worldwide, each exponent bringing their own personality to it.

In the 1970s, Donald Jackson, a Fellow of the Society of Scribes and Illuminators, did much to promote an appreciation of the calligraphic arts in the United States of America. As a result, American scribes and many interested people came together to form societies, in much the same way that Edward Johnston's pupils had done in Britain in 1921. Now it has become a two-way exchange between the old and the new world. American energy and enthusiasm have created a renewed interest internationally, and new societies and groups are constantly being formed. Perhaps there will be one near you, where you may share your interest in calligraphy.

As a form of visual communication, calligraphy is more than just an alternative to print. Like a signature, it can express much of our personality. Colour can do the same. As we seek to express something of ourselves in the choice of subject matter that we calligraph, colour can be used to reinforce the sense of personal expression and achievement. Our eyes can identify over a million colour differences. So let us explore the freedom of a 'calligraphic painter' and throw off the commercial constraints of the printer.

Portrait of St John, folio 291v from the Book of Kells (Trinity College, Dublin).

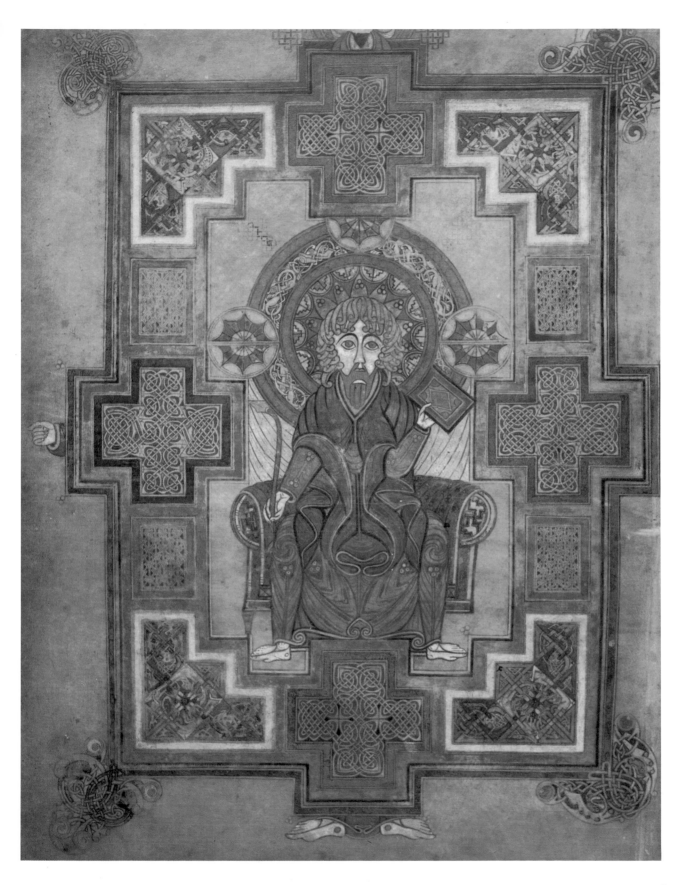

Tools and materials

Calligraphy is a comparatively inexpensive craft. However, do take heed of the saying that 'good craftsmen never blame their tools'. This is because they seek the best equipment possible, to make their work efficient, cost–effective and, above all, frustration-free. So, whether you are an absolute beginner or a prospective professional, buy the best that you can afford to speed the development of your interest and skills. People will quickly admire your work, and their appreciation and commissions will help to offset the cost.

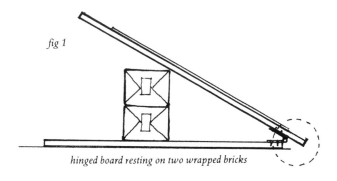

fig 1

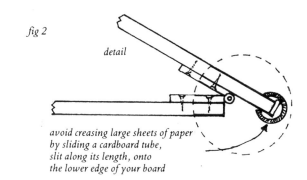

hinged board resting on two wrapped bricks

Work surface

A suitable work surface and a comfortable writing position are both essential for the development of good calligraphic skills.

Writing desk

Compare the price of a drawing board, at least A1 (841mm × 594mm) in size, with two pieces of blockboard from a DIY shop. If the latter is cheaper, then consider hinging two pieces together with nylon or metal hinges, see Figs 1 and 2. A hinged board is much more stable at any angle, but you can work on a free-standing board resting on books or bricks. It is possible to purchase an adjustable easel or support, see Fig 3, or perhaps you could make one. Personally, I prefer a wooden board, although the synthetic surfaces of modern boards are equally good and are easily wiped.

Drawing equipment

Occasionally, I use a T-square for drawing lines, so make sure that you have a straight edge on the left side of your board. I also find a calibrated 60cm (2ft) steel rule and set squares most useful, see Fig 4. Masking tape is preferable to drawing pins for fixing paper to the board as it does not obstruct free movement of hand or instrument.

fig 2

detail

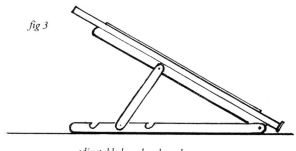

avoid creasing large sheets of paper by sliding a cardboard tube, slit along its length, onto the lower edge of your board

fig 3

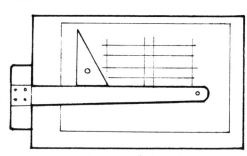

adjustable board and easel

fig 4

T-square and set square

Writing position

Take time to establish a comfortable writing position. Fix this position on the board by placing a protection sheet just below the writing line. This also serves to protect your work from the grease of your hand. Make a pad of three or four sheets of inexpensive paper under your work to give a resilient surface for the pen, see Fig 5. Experiment with the angle of the board. The easy movement of your arm and hand is of prime importance for consistent rhythm and texture in your writing. A steep board will avoid the problem of leaning over your work and also flatten the working angle of your pen. From illustrations it can be seen that mediaeval scribes used an almost vertical desk, with the quill held horizontally. Left-handed writers should try to establish a position that will give fluent left to right movement, see Fig 6.

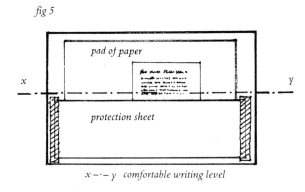

fig 5

pad of paper

x ─── *y*

protection sheet

x ─·─ y comfortable writing level

fig 6

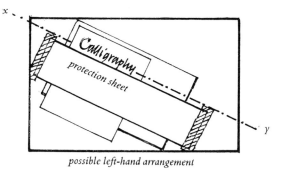

x ─·

Calligraphy

protection sheet

·─· y

possible left-hand arrangement

Pens, pencils and brushes

Because the tool used influences the shape of the letter being created, I would encourage you to explore the range fully and also to try making your own tools from 'found materials' such as felt and green bamboo.

Pencils

These come in a variety of hardnesses. 'H' and 'B' indicate the degree of hardness and softness respectively. 9H is extremely hard, keeps its point well and is essential for drawing on abrasive surfaces. 3H is useful for ruling lines. 6B, on the other hand, is extremely soft and smudges easily. The B range may be useful for rubbing over the back of a design to create a kind of carbon paper before tracing down on the finished job. Always keep a good point on the pencil when you are drawing. Coloured pencils are now available with a watercolour facility. Clean water washed over them gives a painted effect.

Nibs

Pointed nibs are good for drawing and, if flexible, for copperplate writing. Square-cut nibs are essential to the calligrapher. They come with a reservoir on the top or a removable brass reservoir which fits underneath. The reservoir serves to hold the ink or colour. The broader the nib the more colour it will discharge as you

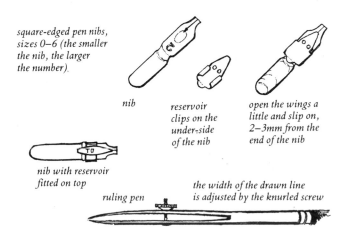

square-edged pen nibs, sizes 0–6 (the smaller the nib, the larger the number).

nib

reservoir clips on the under-side of the nib

open the wings a little and slip on, 2–3mm from the end of the nib

nib with reservoir fitted on top

ruling pen

the width of the drawn line is adjusted by the knurled screw

write. With a steep slope on your writing surface you may prefer to dip your pen in the ink, but with mixed colour it is easier to feed the nib with an inexpensive brush. By feeding the nib behind the reservoir you can keep the lower part of the nib dry. This stops the colour flowing too quickly and creating very wet letters or even blots. The ink is meant to 'pump' down the slit, or slits, in the nib by capillary action as it flexes on the paper when writing. Edward Johnston talked about 'fine writing', one of whose qualities was maximum contrast between the thick and thin strokes in the letter. Uncontrolled ink flow makes such thin strokes difficult.

Left-handers

There are a number of professional scribes who are left-handed. No doubt, if you are left-handed, then you will have found ways of overcoming the frustrations of living in a right-handed world. Maintaining the angle of the nib to the writing line is one of the most difficult things to master because of the position of hand and fingers. To start with, experiment with Uncial forms, see pages 20–21. Also, try the following:

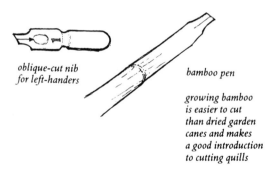

oblique-cut nib for left-handers

bamboo pen

growing bamboo is easier to cut than dried garden canes and makes a good introduction to cutting quills

1. Use an oblique nib, or cut your own from green bamboo.

2. Go for the shapes and rhythm first, and correct the details and angles later.

3. Try moving your paper as far to the left as is comfortable. Because you have to make movements towards and across the body, your rib cage will inhibit free movement. Leonardo da Vinci, being left-handed, wrote from right to left to overcome this problem!

4. Use larger arm movements rather than hand or finger movements, more like drawing at an easel.

5. Tilt your paper so that you are comfortable. Maintain this comfortable writing position by moving the paper up, rather as a typewriter does. Make a note of this position to give consistency to your writing.

6. Position your fingers further up the pen holder away from the nib, so that you can see the letter clearly.

7. Practise frequently for short periods and seek to create 'things' not endless rows of letters.

Fountain pens

These are available with calligraphic nibs and are good for practice and informal work.

Tools for large letters

Because letter size is directly linked to stroke width, the wider the nib the larger the letter. Poster pen nibs which fit into pen holders are made up to 1.2cm (½in) wide. Automatic pens are made up to 2.5cm (1in) wide and 'witch' pens are made up to 0.6cm (¼in) wide. Colour may be used in all of these. Always wash nibs and pens immediately after use.

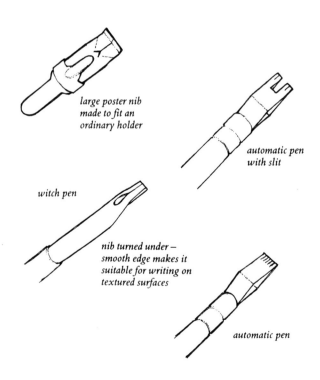

large poster nib made to fit an ordinary holder

automatic pen with slit

witch pen

nib turned under – smooth edge makes it suitable for writing on textured surfaces

automatic pen

Brushes

The finest and most expensive are made from sable hair. Watercolour brushes are most suitable and, with care, will last for many years. For very fine work use a size 000 brush. A number 3 and number 6 are also useful. Simulated sable brushes made from nylon are excellent, particularly for one-stroke lettering. Buy several inexpensive nylon brushes for mixing colour. One for each hue is useful. When applying large areas of watercolour on stretched paper, a large soft-haired or mop brush is essential. Mix enough watercolour and work quickly on a sloping surface, laying the colour from side to side and down the board. Charge the brush fully so that the colour flows and the working edge is kept wet.

Care of brushes

Do not leave brushes standing in water. Wash them thoroughly. Do not allow the paint to dry at the base of the brush, near the ferrule, as this will cause the hair to spread at the point and even break off. Dry brushes to a point. Take care when using waterproof inks, acrylics and adhesives, and wash out immediately before they dry. Never use sable brushes for waterproof media.

Gilding burnishers

Burnishers for polishing gold leaf are made from highly polished agate or haematite. They are available from specialist suppliers. Keep them free from grease and wrap them in a soft cloth or chamois leather to keep them scratch-free.

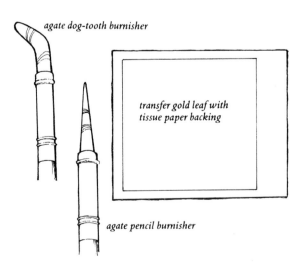

agate dog-tooth burnisher

transfer gold leaf with tissue paper backing

agate pencil burnisher

Inks and pigments

There is a vast selection of colours and media from which to choose, and, in order to discover their full potential, it is a good idea to explore the range a little at a time.

Chinese inks

Black and vermilion come in sticks and need to be rubbed down on an ink stone, or a saucer with

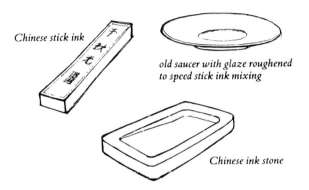

Chinese stick ink

old saucer with glaze roughened to speed stick ink mixing

Chinese ink stone

its glaze roughened with an emery cloth, to make mixing quicker. Distilled water and rainwater seem to make the blackest ink.

Non-waterproof or water-soluble inks

These may be used in nibs and fountain pens. Cartridges are available. For outside use, such as on posters, a weatherproofing may be achieved by treating your work with a clear wax furniture polish.

Indian ink and waterproof inks

These inks may be thinned in distilled water. Although an exciting range of colours is available, the shellac in the ink dries quickly in the slit of the nib and in brushes. However, it does dissolve in methylated spirits.

eye-dropper for measuring distilled water

INK

Felt-tipped pens

These come in a variety of shapes and sizes, and may be cut with a sharp craft knife to offer exciting possibilities. Notches may be cut to give an open line stroke. The ink is spirit-based and waterproof, or water-soluble. The spirit-based inks have a characteristic smell. For larger posters or expressive work, try wrapping felt over a ruler, or try using underfelt or felt wrapped around balsa wood in a bulldog clip.

will affect the flow and rhythm of your writing and, therefore, its finished appearance. To clear any drying pigment which can clog the free flow of colour, I find it helpful to wash out the nib every paragraph or so. This is important when working in a dry warm room. Mediaeval monks did not have this problem as they usually worked in the cloisters, as at Gloucester Cathedral, or in large rooms open to the elements.

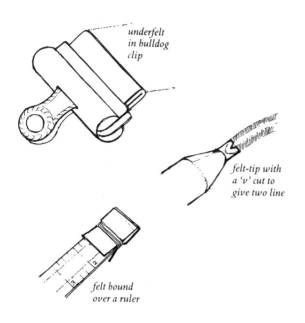

underfelt in bulldog clip

felt-tip with a 'v' cut to give two line

felt bound over a ruler

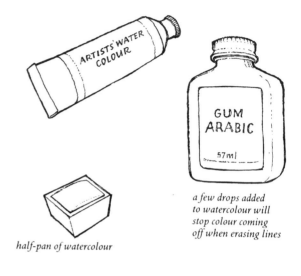

half-pan of watercolour

a few drops added to watercolour will stop colour coming off when erasing lines

Watercolours (artist's quality)

Watercolours, sold in tubes or small cakes, are finely ground pigments of high quality, and are favoured by most calligraphers when work demands the finest materials. They are, by nature, translucent and this is an essential part of their freshness. They may be used thinly to give a variety of tone to the letterform, or mixed more thickly, rather like a gouache. Blues and greens will need the addition of a little Chinese white to give body and opacity. Vermilion does not need this. They also have a limited amount of binder with them and it is advisable to add a few drops of gum arabic. Mix the colour to a creamy consistency, rather like the top of the milk. An eye-dropper and distilled water make mixing that much easier. The colour should flow through the slit in the nib easily. If it does not, then it is worth taking time to rectify this because any problems

Gouache or designer's colours

These come in tubes and are finely ground, opaque, water-soluble colours with good covering power. They may be used from the tube and mixed with water to a creamy consistency. This must be done where large areas of flat colour are to be laid down as a background. When thinned they flow from a pen easily and are excellent for rough designs and less permanent work. Some pigments are subject to fading, but the degree of permanence is indicated by most good companies. The white is very good for labelling on black or coloured papers.

Acrylics

These open up the possibilities of writing on flexible textured materials for banners, and letterforms may accompany or become the basis for collage and embroidery. It is best to use a square-edged, one-stroke brush. The paint may be thinned with gloss or matt media and water to achieve free flow without it spreading or bleeding into the fabric. When dry the pigment is waterproof and flexible, and does not need fixing.

Resists and masking fluids

Wax crayons may be used to create very interesting textures. Letterforms may be produced and washed over with translucent watercolour, waterproof inks, or dyes. The eye-catching effects are useful for visual communication, such as on posters and bookjackets. Finer calligraphic results may be obtained from masking fluid, which may be used in a brush or pen. When the writing in masking fluid is dry, colour may be washed across it, and when this is dry the masking agent may be rubbed away, revealing the white paper or original background. You may find it worth exploring the wax-resist dyeing process called batik on both paper and fabric.

Bleach

For more ephemeral works, interesting results may be obtained by writing with diluted household bleach, one part bleach to fifteen parts water, on coloured papers or prepared coloured surfaces, e.g. over waterproof ink. It should be very dilute because, over a period of time, it may destroy the paper fibres and there is no easy way to reverse this.

Dyes, stains and fabric paints

A wide number of these exist on the market and they can extend your repertoire of effects considerably. Try creating personal designs for members of the family using fabric paints on T-shirts. They can be calligraphed, painted, sprayed, or spattered over cut stencil letters of your own design. To allow the clothes to be washed the colour is 'fixed', usually by ironing with a hot iron.

Gilding

Gold has been used as a precious pigment from earliest times, imparting richness and colour as it reflects the surrounding shadow and light. Traditionally, gold has been attached with a variety of sticky substances, such as natural gums. In mediaeval times, gesso was used where the gold was to be particularly bright, and today it is still used for this purpose. The ingredients and careful preparation of gesso, however, are beyond the scope of this book.

As an alternative, I have selected something which is more readily available in most art shops. This is gloss acrylic medium, used for acrylic paints. This can be thinned down, using five parts distilled water to five parts medium, and will flow through a pen or can be used in a brush. Because it is clear, it is necessary to add a little colour to it in order to see what you are writing. Red is a good traditional colour under gold. If the mixture is too rich or the medium used at full strength, then you may find that it crinkles or reticulates on drying and will stop you achieving a smooth surface. A rough surface will mean that your gold will not be bright and smooth.

If you want your design to be slightly raised, then it is best to use two layers of acrylic medium. This slightly raised section, like a flattened dome, allows the light to catch the gold and reflect back. Wash brushes and nibs immediately after using acrylic as it is waterproof when dry.

Once dry, the acrylic is ready to receive the gold leaf, which comes in small books of twenty-five leaves and is not as expensive as you might think. Use transfer gold which comes attached to thin paper and may be handled with ease.

Take out a page of gold holding the paper surround, otherwise the gold will stick to your fingers. Make a small tube, approximately 15cm × 0.6cm (6in × ¼in) by wrapping paper around a pencil, see Fig 1 overleaf. Use the tube to direct your breath onto the acrylic design (three or four breaths). The slight moisture content will give a little extra adhesion to the surface and allow the gold leaf to stick more readily.

Immediately apply the transfer gold, and rub down through the transfer paper with the pad of

your finger, see Fig 2. With a second sheet of thin paper, complete the process with an HB pencil, rather like taking a brass rubbing, see Fig 3. The pencil will allow you to gently feel the outline and contours of your design. Take particular care to rub down the edges. Do not press too hard or pencil marks will appear as a texture on your gold surface. The second sheet of thin paper stops the back of the transfer gold from getting blackened by the pencil. Remove the paper carefully and then brush away the surplus gold with a dry, soft brush, see Fig 4. Add more layers of gold leaf if you need to.

Finish off with a burnisher through a very smooth paper called glassine, see Fig 5, and then work directly onto the gold if you wish to polish it even more brightly. The glassine allows you to see any slight blemishes or missing bits of gold. Add more gold at this stage where necessary – by repeating stages 1, 2, 3 and 4. Do remember that this gold will never be as bright as in traditional recipes.

A pencil burnisher will allow you to press into the surface of the gold with a pattern, e.g. dots or lines, and these depressions catch the light. Large areas of gold were patterned or punctured in this way in mediaeval times, as this not only added interest but also disguised any unevenness where the craftsman had to work quickly.

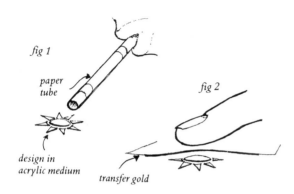

fig 1

paper tube

design in acrylic medium

fig 2

transfer gold

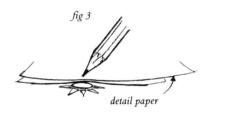

fig 3

detail paper

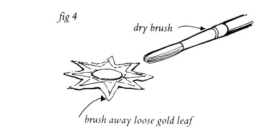

fig 4

dry brush

brush away loose gold leaf

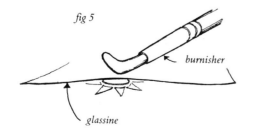

fig 5

burnisher

glassine

Papers for calligraphy

Selection of paper is very important. Poor quality paper will discolour and it may cause the ink to spread or feather, particularly in fine writing or where using a large pen or brush. Good quality paper will allow you to erase mistakes. Always test a paper before buying large quantities – try it on the corner with a fountain pen. Wherever possible, avoid rolling paper because it does bruise or mark. If it must be rolled in order to carry it, then roll it around a tube of reasonable diameter as a support.

There are three main types of paper for calligraphy:

Machine-made papers

There is a bewildering array of writing, drawing and printing papers. Calligraphy normally requires smooth papers which may have been made for writing, printing, drawing or painting.

You may be familiar with the lightweight 'bank' or layout papers, or heavier stationery 'bonds', but may not have thought of other unlined writing papers like ledger papers. Writing papers are well sized to avoid the ink bleeding or feathering into the surface of the paper as it would on blotting paper. Stationery is now being offered in a large variety of colours and is very

suitable for small anthologies and books. It is worth making enquiries at a small obliging printer or paper merchant to see whether larger sizes are available. Some paper merchants supply A3 designer sample pads, which are excellent value. Drawing paper is available in large rolls. Smooth or matt-finished white cartridge papers are also good. These are available in a range of strong colours too, and are sometimes called cover papers. They are excellent for cards and display work, particularly when writing in white or in tints of the background colour. Very shiny or coated papers should be avoided as the ink will spread or stand in blobs on the surface.

Mould-made papers

These are amongst the best and most readily available papers for calligraphy. They are machine-made in small quantities and have many of the qualities of handmade papers. They are well sized, strong and have a high rag (i.e. cotton or linen) content.

Ingres, a popular mould-made named after Jean Auguste Ingres the French painter, comes in a variety of beautiful colours. There are Swedish, Italian and American versions of this paper. Whenever you have a choice write on the smoothest side, particularly if the writing is small, because it can be fibrous at times.

Most mould-mades have a distinctive pattern imparted by the pattern of fine wires which act as a mesh in the mould to catch the fibres of paper.

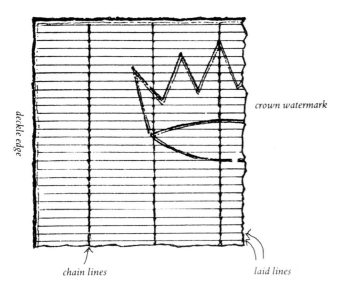

deckle edge

crown watermark

chain lines　　*laid lines*

Handmade papers

These are very fine papers made from cotton or linen. Each sheet should have a watermark and deckle (i.e. rough) edges, which are distinctive to the making process. Each sheet is made individually. It is traditional to maintain the deckle edges as a hallmark of quality. Handmades do not have a marked grain direction.

Look and ask for the hot-pressed finished handmades (H.P.); the rough or not pressed are not suitable for fine calligraphy because of their textured surface, but they may be exploited in more experimental or larger works. These papers are expensive, so take care in selecting them, especially when buying in quantity. Specialist paper suppliers have sample swatches of calligraphic papers. Whenever possible, try writing on a sample before purchasing to safeguard against ink spread or feathering.

Handmades can bring added quality to work, and are essential where work is expected to last and high standards of appearance and finish are required.

Japanese papers　The Japanese create some beautiful handmade papers using long vegetable fibres which make them very strong. They come in a range of colours and their soft surfaces make them suitable for the wide pen, reed and brush letters. They are excellent for creative and experimental calligraphy where the surface quality and colour become an essential part of the expression.

Decorative papers　Decorated papers, like marbled papers and Japanese-dyed papers, are also worth exploring. They are attractive in themselves and may inspire unusual ideas.

Measurement and weight

A number of traditional paper sizes remain in use, particularly in America, e.g. crown, foolscap and imperial. However, in Europe paper is now most often measured and weighed in centimetres and grams as determined by the International Standards Organisation (I.S.O.). The I.S.O. standardized size and weight on a rectangular sheet of paper measuring 841×1189mm (a golden section proportion). This sheet size is called A0 and is weighed in grams, expressed as grams per square metre (g/m^2). Each time the sheet is folded in half it becomes A1, A2, A3, and so on. In Europe, we are most familiar with A4

(210 × 297mm). The grammage gives an indication of thickness; stationery is approximately 80g/m², Ingres 100g/m², cartridge 130g/m², and a heavy handmade might be 200g/m².

Paper stretching

The heavier the paper the less likely it is to cockle. But, if you are working with watercolour in large areas, then it is advisable to stretch the paper first.

Dampen the paper under a tap or with a sponge. The paper fibres will expand if left for a few minutes. Lay the paper flat on the drawing board and tape around it with gummed paper tape, 2.5cm–5cm (1in–2in) wide. Rub the tape down well and allow to dry slowly, away from direct heat. You will now be able to work on the paper without it cockling.

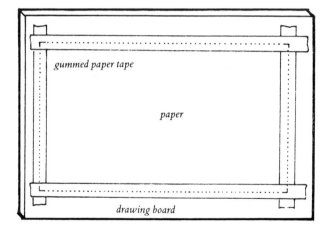

gummed paper tape

paper

drawing board

General points

1. Avoid polished, greasy or coated papers.
2. Work on the smoothest side of the paper.
3. In manufacture, machine-made papers have their fibres aligned in one direction, which gives them a grain. Folding parallel with the grain is easier. Testing which way the paper will flex most easily will establish grain direction and make for better functioning books and sharply creased cards because the fibres are not cracked or bent.
4. Erasures may be made with an ink, pencil or typewriter eraser. The disturbed surface and fibres should be burnished flat through thin layout paper (to avoid making the area polished) before writing in the correction. Alternatively, the correction may be written in and the offending detail 'picked out' with the edge of a sharp razor blade or sharpened eraser. This avoids the problem of feathering. Thinner papers make erasures more difficult, if not impossible.
5. Layout pads are invaluable; they take ink well and are suitable for presenting artwork to the printer for plate-making. Layout paper and tracing paper may be obtained in rolls for banners, large work, inscriptions and rubbings.
6. Odd rolls of wall and lining papers make inexpensive practice papers.
7. Photocopying machines will now accept many of these papers, producing coloured prints, reductions and enlargements from your designs. Full colour reproductions are also available.

Vellum and parchment

These are made from calf and sheepskin respectively and have qualities all of their own. However, they need preparation before work can begin successfully. They are available from specialist suppliers or straight from the manufacturers.

Examples of paper

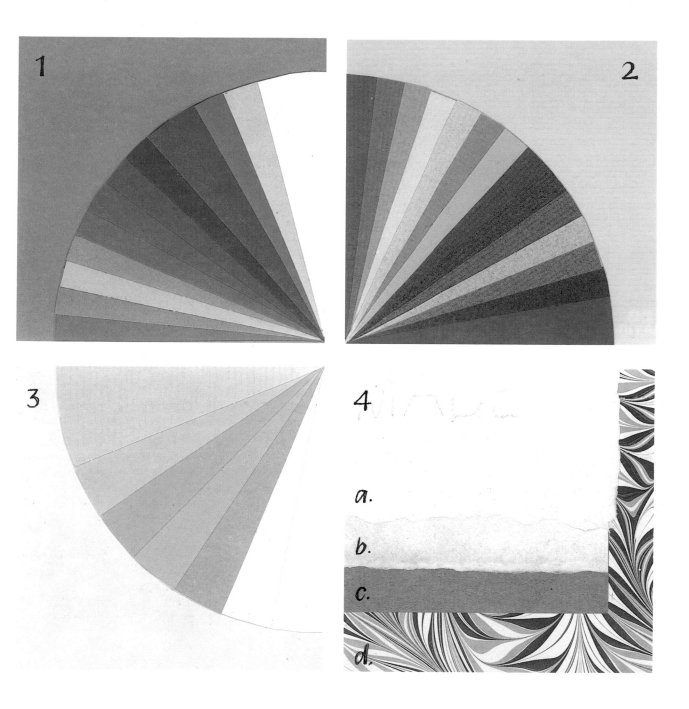

1. Cover papers. 2. Ingres. 3. Stationery or writing
papers. 4. Handmade papers: a, b. English hot-pressed;
c. Japanese; d. hand marbled.

Colour

For many of us, the black and white world is a safer world. A page of fine writing or fine print is a joy to behold, and has much to teach us about the balance of contrast, shape and texture. Look at the range of 'colour' an artist like Aubrey Beardsley gets into one of his black and white illustrations.

So, how can we begin to discover the world of polychrome? Perhaps we need to understand some of the vocabulary in order to think 'colour' and, most importantly, to build and explore a personal colour experience and heighten our awareness.

Colour vocabulary

The first step is to begin to build an understanding of colour theory.

The primary colours are red, blue and yellow.

The secondary colours are orange (yellow and red), violet (red and blue) and green (blue and yellow).

Tertiary colours are mixtures of primary and secondary colours, e.g. blue and violet = blue violet.

Hue is the quality which distinguishes each individual colour.

Tints, sometimes called pastel colours, are basic colours or hues mixed with white, e.g. pink.

Shades are basic colours or hues mixed with black, e.g. navy blue.

White and black are neutral tones and not considered to be colours; mixed together they produce a range of neutral greys. When all three primaries are mixed they also give a grey.

Chroma is the brightness or intensity of a colour, e.g. primary hues are most intense and saturated.

Tone and contrast indicate the lightness or darkness of a colour, e.g. yellow is a lighter tone than blue or red, but primary blue is darker than both. The greater the contrast in tone when colours are put together, the more attention they will attract.

Simultaneous contrast is a term derived by Eugene Chevreul, a nineteenth century French dye master. He discovered that colours appear to vary according to their size and relationship to the surrounding colour.

Temperature refers to the apparent warmth or coldness of a colour, e.g. reds appear warm and blues appear cold. Also, some colours have more energy and power to attract whilst others are quiet and retiring, e.g. reds come forward, blues recede. (See colour energy, page 33.)

Symbolic colours are those usually associated with a particular event or emotion, and they can vary from culture to culture, e.g. white is often regarded as a symbol of purity and, in Britain, is traditionally associated with weddings. Colour also communicates quite powerfully at a subconscious level, and manufacturers frequently exploit this when choosing the colour of their product packaging. You might consider the symbolic aspects of colour as you seek to complement visually the ideas expressed in a piece of literature or use colour effectively in publicity material.

Colour experiments

Through practical experiment, it is possible to gain some idea of what colour can achieve.

Collage
From available printed colour, magazines and so on, make a colour collage which explores each of the primary colours in turn, e.g. explore the family of yellows. Try to establish at what point

Colour wheel

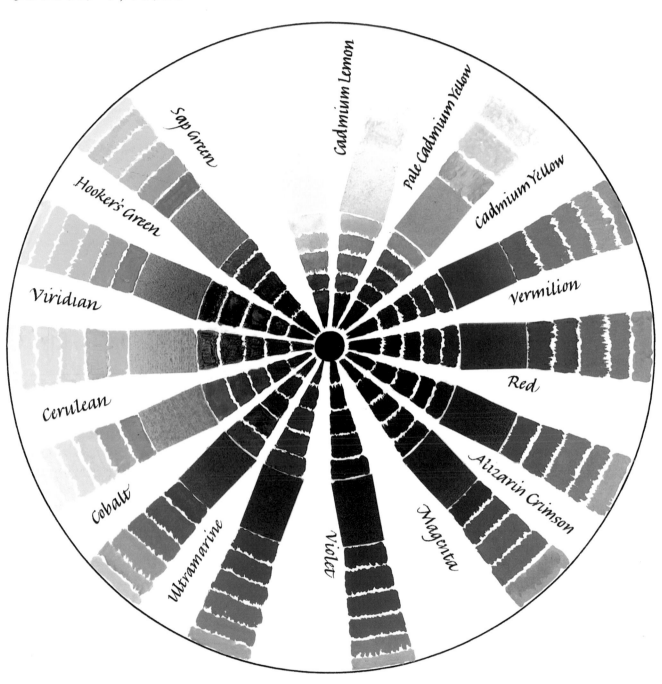

The colour wheel is one of a number of structured ways of exploring colour. Use it in conjunction with the experiments given here to discover how colour functions in a variety of relationships and situations.

the warm or chrome yellows become orange and the lemon yellows become yellow green. Is there some order in the arrangement? What happens if you centre the lighter tones or enclose the darker tones with lighter ones in a circular formation? Try this with your favourite colour. Can you say why it is your favourite colour?

Colour mixing

Although a variety of torn and cut paper shapes and letterforms can be used in visual communication, your own mixed colour will be used in pens and brushes for calligraphy. Take two primary hues and try making a colour scale in ten or twelve steps, e.g. from blue through to green to yellow. When mixing, always add the darker hue to the lighter, a small amount at a time. Can you decide which is the mid-point on your scale? As you grow more experienced, can you produce a scale which moves smoothly from dark to light? You will find that you will be able to identify the particular pigments in a colour. Try exploring tints and shades in the same way, as well as the range of neutral greys which may be given a little more interest with a touch of colour. Some calligraphers make a note of particular mixtures for reference when planning new jobs or as a means of matching particular colours used in previous pieces of work. Work in a consistent light. Daylight is very different from artificial light, particularly when mixing violet/purple hues.

Colour is intensely personal, but by exploring through mixing you will discover new arrangements and may even grow to love some that you were not sure about before. So, have fun and be outrageous.

Colour in nature

A rich source of colour experience and study can be found in plants, bark, rocks and other natural forms. The emphasis here should be on recording by colour matching and by estimating how much of each colour is used in relation to the others, e.g. in a pansy the small centre of orange yellow is often set against a larger area of dark velvety purple. Drawing correct shapes is not important, but attempting to identify the mix of colours needed to create them is. As well as reinforcing

your colour mixing experience, this may offer new and interesting colour relationships.

Artist craftsmen

Rather like natural sources, good reproductions can be used to examine practically how other makers have used colour in their particular time and culture. Perhaps they had a smaller range of colours or cultural constraints. Such constraints often lead to greater inventiveness. For example, Islamic surface decoration in geometric and calligraphic pattern making is probably unsurpassed because of the Koran's teachings about the representation of natural form.

The work of painters may offer ideas for composition as well as colour. You may be anxious that this may appear to be copying and that your work will be derivative. But, like language itself, we begin by mimicing the sounds of those around us. To choose to be deaf is a terrible choice.

If you are happy to follow a written exemplar, then you can also examine in detail the colour relationships, composition and expressive qualities of those who have spent a lifetime handling colour. Your personal and informed response will come through, adding another unique touch to your written hand.

Using colour effectively

Although rules may be broken and the argument sustained that they are out of place in the arts, it is worth taking account of the rich heritage of artistic experience as certain recommendations are helpful as starting points.

Related or harmonious colours

These are colours which are adjacent on the colour wheel, appear pleasant together and provide a sound basis, e.g. yellow, orange. It may be said that they have something of the

neighbouring hue in their make-up and are related and harmonious. This is useful to know, not only in the preparation of colour for working on coloured papers, but also in the selection of materials for final presentation, whether it be binding, mounting or framing.

Complementaries

An interesting phenomenon, which has to do with the way in which we perceive colour, results from the colour receptors becoming fatigued or saturated by one hue. As if to compensate, they produce an after-image of another colour, known as a complementary hue. This complementary hue may be found opposite on the colour wheel, e.g. yellow–violet, red–green, blue–orange, or by mixing the remaining two primary colours. Artists have found that it is effective to have a small area of complementary colour in a picture or design in order to give it a certain life and sparkle. The complementary colour intensifies the main colour.

It follows from this that colours react or respond to one another and care should be taken to observe this. Their appearance on the palette may change on the piece of work to heighten and enhance or mar. Lovely examples of this are to be found in the Lindisfarne Gospels and the Book of Kells where, by using a purple tinted line, the yellow pigment orpiment is made to glow, rather like the gold in later manuscripts. Also, a thin line of colour, as in a letter stroke, will not appear as colourful as it does in an area and may appear darker in tone.

Complementary colours, then, are those which help to complete or make another more vibrant. Each colour has its complementary, and, to obtain maximum effect, these need to be handled sparingly, e.g. in John Constable's landscape of Dedham Lock the red ribbon in the horse's mane is tiny.

Discordant colours

If you take the analogy of music and the notion of a natural scale, then you will appreciate how effective discords can be. Discords, or clashes, in colour can be equally disturbing and effective in the visual arts. Their presence may bring an expressive element to the form of communication, e.g. by way of protest in a poster or to emphasize the theme of a poem. To reinforce the message, the calligrapher may also select or adapt the letterform to add a sharp, angular or dramatic dimension. Discordant colours will often appear to vibrate visually when close together, disturbing and compelling the viewer. One way of creating discords is to invert the natural order of tonality. You have seen that blue is normally darker than red, and yellow lighter than both. By adding white you can lighten their tone. Red may be made pink and lighter in tone than warm yellow or orange. When put together they appear to be hot and sugary.

The most dramatic discord is where violet is lightened to a pale lilac and set alongside a warm yellow which is actually darker in tone. You can often appreciate similar discords in nature, e.g. where the yellow pollen in flowers is set alongside pale tints of violet and green.

Letter shapes

Craftsmen have been inspired down the centuries by the drawn and chisel-cut letters on Roman monuments, regarding them as a model of beauty and legibility. Consequently, they have been adapted many times, for use in different situations using other tools and materials. Because the tool influences the shape of the letter, particularly its details, the shapes have changed, usually to allow them to be made more quickly. The stylus scratched into the wax tablet allowed the Romans to write quickly. The square-cut quill, with its flexibility, needed more care but responded beautifully to the natural movement of the hand. As a result, with the development of the cursive or running hand, more rounded letterforms emerged. The geometric capitals underwent the greatest transformation. The small letters, or minuscules, became the norm and the capitals were used more and more for emphasis and decoration.

Today, there exists a bewildering array of different shaped letters and typefaces. By way of introduction, I have selected letterforms which will give you a variety of shape and weight to your work.

When letters are put together they create a characteristic pattern and texture which you can exploit. You are already visually sensitive to type or letterform and can probably recognise your newspaper by its texture and layout alone, without seeing its mast-head name. Thus, even in black and white, it is possible to talk about families of letter shapes having a distinctive colour and tone. Like someone selecting threads to give a change of texture in a piece of weaving, consider your letter shapes in the same way on your design.

Remember, especially when designing posters, that minuscules are more immediately legible than majuscules (i.e. capitals). Minuscules are used internationally on motorway signs and wherever fast visual communication is necessary.

Uncials

These chunky, majuscule letterforms provide a weight of colour which more elegant later forms may not supply. Their unusual appearance can excite interest and add to the overall impact of a design.

Uncials were in use in Europe from the fourth century. They evolved from the Roman letter and demonstrate how letter shapes change when the natural movements of the hand, combined with a quill on parchment, bring greater speed and flexibility. Geometrical shapes like M became rounded and ascenders and descenders began to develop in the letters D and P. These continued into the Half-Uncial form and later emerged as the minuscule or lower case alphabet.

Uncial forms have strong associations with the Celts, and the Book of Kells and Lindisfarne Gospels are fine examples of both Uncial and Half-Uncial hands. You might use Uncials where the historical or cultural context permits, or where the work is dignified or meant to be read slowly.

Holding the pen with the nib parallel to the writing line is uncomfortable at first and also gives thin horizontal strokes. So, a shallow angle of 5° is often preferred. This will give greater thickness to the horizontal strokes and improve legibility. The monks were able to cut their quills obliquely to allow a more natural hand position. You could try this yourself using bamboo. Uncials require the use of the corner of the nib to draw in the serif shapes (i.e. cross-lines finishing off the strokes of the letters), before filling the serif with ink. In the example shown opposite, I have tried to indicate this by shading in red the corner of the nib to be used. The flexible quill allows this to occur in one movement.

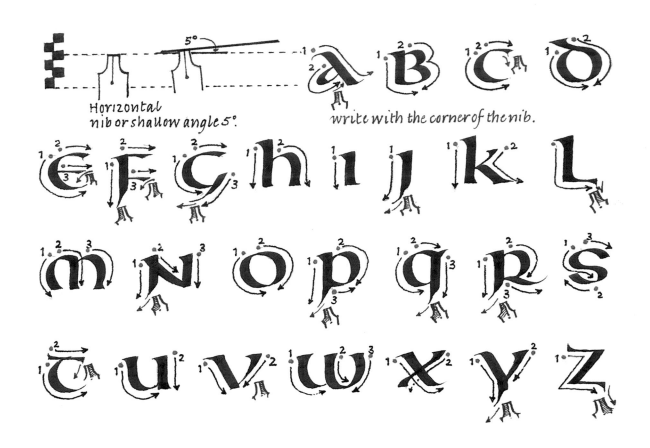

Horizontal
nib or shallow angle 5°.

write with the corner of the nib.

·LATIN·PATRICIUS·NOBLEMAN·

SAINT

Apostle · of · Ireland ·

PATRICK

·whose·original·name·was·sucat

This lettering makes use of two sizes of the Uncial letterform. The large Uncial was written with an automatic pen. The colour was adapted from the Portrait of St John page in the Book of Kells and is deliberately patchy to acknowledge the patina of age and the fact that two tones of blue were used on the page.

Gothic

Developed in the twelfth century, Gothic is a very angular, upright and densely-packed letterform. It is a good hand with which to start because the vertical pen strokes and diamond, or lozenge, shaped heads and feet give a good appreciation of what the pen will do, without wrestling with the subtleties of circular forms like the Foundational hand (see pages 28–29). It is fun to get the sense of achievement and progress that the lower case alphabet will permit whilst increasing your skill and understanding. The capitals are more difficult to write.

Majuscules Examples of majuscules differ, particularly in detail. Mediaeval examples are comparatively few as the monks favoured the Versal-drawn letters which were in use at the same time (see pages 24–25). Most are from the Victorian period when neo-Gothic design was at its height and this letterform would have expressed quality and timeless values. Gothic majuscules survive today in newspaper titles, printers' specimen sheets, and in association with ecclesiastical and legal institutions. I have simplified the majuscule examples shown opposite; perhaps you could begin a collection from other sources. Never put majuscules together as they become indecipherable.

Minuscules – making a start With two pencils taped together or a wide nib (No. 2), create a closely packed set of vertical lines, taking care to space them evenly. The aim is to create an even and consistent texture. Practise this until you get the feel of it. Then add the diamond-shaped heads and feet to the vertical strokes to create the basis of this family of letters. Compress the letters so that the space between them is the same as the counterspace inside each letter. The space between words should be the width of a minuscule 'o'.

This compressed letter shape takes up less space. Its use became increasingly widespread from the thirteenth century as it allowed more books to be written using less vellum and parchment which were scarce and expensive. For ease of reading, the line lengths were kept short with little space between lines (interlinear spacing). The result was the double or multi-column page which is still seen, e.g. in bibles, modern newspapers and magazines. In design, remember that the longer the line of text the wider the interlinear spacing should be, to allow the reader to find the next line with ease.

Gothic can be very decorative, having a strong pattern value and tone. I believe that its cultural associations limit its use, but try it in a variety of colours. A split pen will give an open stroke to the letter, which will cause it to flicker and sparkle. Children seem to like Gothic and find it exciting and rewarding too.

Using an automatic pen with a split nib, I rounded the angular Gothic forms to give a more contemporary flavour. The white line of the open letter gives a sparkle to the letterform and, because of its cultural associations, it may be suitable for use on wine labels and some record sleeves.

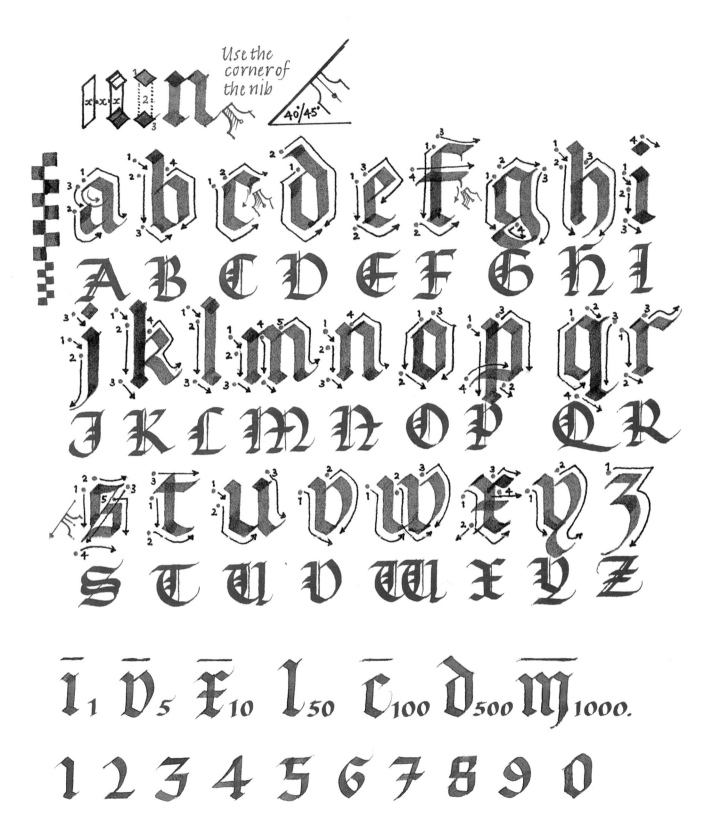

Use the corner of the nib

40°/45°

Gothic numerals used Latin or Roman forms. They were distinguished as numerals by a horizontal line. Arabic numerals were introduced as a result of the crusades and Eastern trade, and modernised forms can look like these.

Versals

Edward Johnston used the word Versal to describe the colourful quill-drawn capital letters which began verses and paragraphs in mediaeval manuscripts.

These mediaeval capitals are 'elastic', expanding or contracting and even joining – sharing each other's limbs as space will allow. They may be used playfully and spontaneously as confidence and circumstances will allow, or carefully planned and traced down for more formal work, e.g. title pages.

Versals are compound letter shapes created from a series of strokes using a pen or a quill as the monks did. In order to get the spacing and organisation as you would wish, you might try painting them with a brush over a planned drawing.

The stroke width may be large, at times allowing for some decoration or added tints of colour to quieten the hue of the base colour. Where a more linear texture is required, the letterforms can be left as open shapes, e.g. as in the E, F and B illustrated here. These open letters are also useful where very large letters are

EFGHIJKLMN
OPQRSTUVW
XYZABCD
oegghjkmnrtwy

A more decorative alternative is the Lombardic form which is based on the rounded Uncial letter shape.

Versals may be set at the edge of the text or partly within it. Used in this way, it is traditional to make the letter height a multiple of the writing line height, e.g. three lines of text high.

required as space filling and would be too heavy if painted solidly.

In formal work it is advisable to maintain the proportions of the classical Roman letter, observing sound letter spacing (see Foundational hand, pages 28–29).

Modernised Versals

These are pen-drawn forms which have a lightness and spontaneity about them because they have no serifs. Like mediaeval Versals they can be expanded or compressed or used to demonstrate your knowledge of classical letter proportions.

The nib width may be chosen according to the size of the letter – wider for tall letters. This will allow for the two pen strokes to be drawn coming together at the centre to give a narrowing, or entasis, to the letter stroke. This entasis also imparts an elegance to the letters which is the handmark of the maker, something clearly non-mechanical.

The letterforms may also be made heavier and chunkier where a stronger sense of colour is required or as befits the subject matter. Forms like these are to be found on early Italian medals and inscriptions, and were the inspiration for Bertholde Wolpe's popular Albertus typeface of 1938. Optima, a typeface designed in 1958 by Herman Zapf, is another interesting model with formal lower case shapes.

Modernised Versals are wonderful forms for informal visual communication such as greetings, party invitations, posters and banners. The shapes can be made to dance about, even lean this way and that, so that you are freed from notions of horizontal and vertical lines. From playful doodling, allow your confidence to grow and your understanding to progress, perhaps using felt-tipped pens with their range of translucent colours.

AB
CDEE
FGHIJ
KLMN
OPQR
STUW
VXYZ

Italic

This is a speedy, flowing, cursive hand which emerged from Renaissance Italy. It has the potential for beautifully elegant formal work with a lightness which complements and contrasts with rounder and heavier forms.

The degree of slope from the vertical is one of personal preference and seems to vary according to the scribe from 5° to 12° from the vertical. The exemplar is approximately 10°.

Strangely, the Gothic fencing-post approach, more openly spaced, may be used effectively to arrive at an even texture of letter space. You should aim naturally for the same sense of space between the letters as within the letters.

The capitals should be carefully mastered and understood before attempting the flourished and swash versions. The flourishes should appear spontaneous (very difficult if you are nervous) and complement the available space. They should be the natural extension of the limbs of the letters.

Poetry and more elegant visual communications lend themselves to a variety of Italic forms, e.g. see how many perfumes are so labelled. If you make Italic your everyday hand, for writing your envelopes in particular, then see how many compliments you will attract. Practise and make the postman's day!

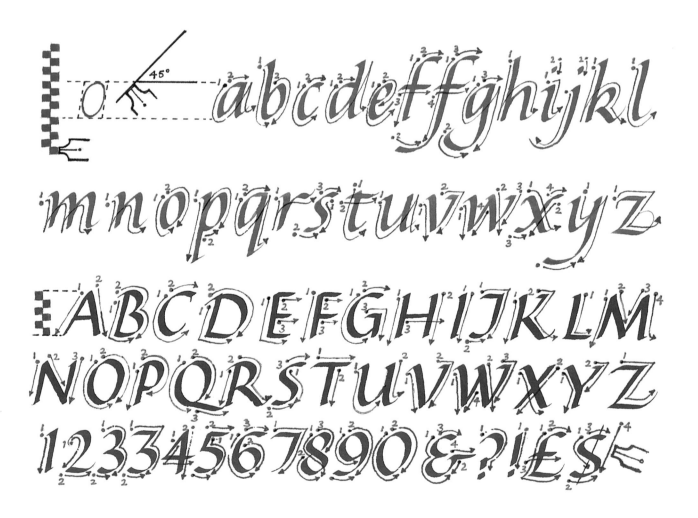

Flourished Capitals

A B
C D E E G
H I J K
M N P Q
R S T T U
V W X Y Z

Council

London

Sun

Foundational

This hand was developed by Edward Johnston and is based upon tenth century writing from the Ramsey Psalter, with the O having a characteristically circular form. Edward Johnston found that the I and the O often revealed the essential characteristics of any written alphabet.

The proportions of the majuscules are based upon the finest of Roman inscriptional letters. Be careful about spacing these letters. To arrive at a good even texture, space the letters to give the same 'visual area' between each one. Some open letter shapes, e.g. T, L, O, C and G when used in a word require that the other letters be eased apart to accommodate this.

With increased skill, the capitals may be made taller and more elegant, e.g. 10 nib widths high. Chunkier versions, e.g. 5 nib widths high, are suitable for use on posters.

Foundational is an extremely legible hand and may be used with confidence for formal and more general work. It also contrasts well with the lighter, freer Italic texture and it is not unusual to find the two together, e.g. with the Italic used for footnotes.

Herren velsigne dig og bevare dig
the LORD bless thee, and keep thee:
Herren lade sit ansigt lyse over dig
the LORD make His face shine upon thee,
og være dig naadig
and be gracious unto thee:
Herren løfte sit aasyn paa dig
the LORD lift up His countenance
og give dig fred.
upon thee, and give thee peace.

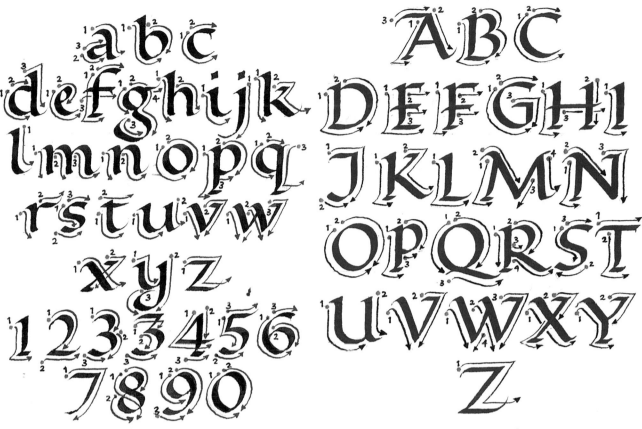

abc
defghijk
lmnopq
rstuvw
xyz
1234567890

ABC
DEFGHI
JKLMN
OPQRST
UVWXY
Z

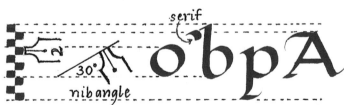

serif
nib angle
30°
obpA

Proportions of Capitals
⊠ "Square" O Q C D G M W
◪ ¾ A H K N R T U V X Y Z
⊟ ½ E F I J L P B S

Design and layout

Just like a choreographer who has to consider not only the movements in the dance but the space in which they are to take place, I think that it is important to consider the shape and space available to us. Sometimes the task will dictate it, at others we may have complete freedom. Because contrast in colour creates interest, let us consider the aspect of contrast by way of a brief introduction to layout.

Contrast of dimensions

Squares, with their equal sides, appear to be more formal and less visually exciting than rectangles. The contrast in measurement in the latter creates a more interesting shape in which to work. Perhaps this may also be true of circles when compared with ovals.

The contrast between text and clear space

Even though parchment was expensive, the monks used very handsome margins to set off their work, aid legibility and conserve the text. It is worth adapting these tried and tested visual principles in your own work.

Traditional page layout Divide the height of the page into sixteen units. A strip of paper the same height folded four times will give you the unit measurement and is quicker than a ruler. Multiples of this unit will give the margin sizes. Generally, the top margin is half the width of the bottom and can either be the same width or slightly less than the sides. On a double page spread, the centre margin is made equal to the two side margins to give three columns of equal width across the two pages. Traditional margin sizes are two units at the head, three at the sides and four at the tail, see Fig 1. For smaller margins, divide the page into twenty units or try one unit at the head, two at the tail, etc., to give a greater working area.

A more open page layout with lots of light or space in the text does not need large areas of margin space, or even margins at all! So rules may be broken.

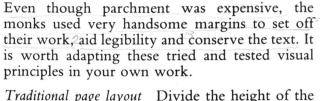

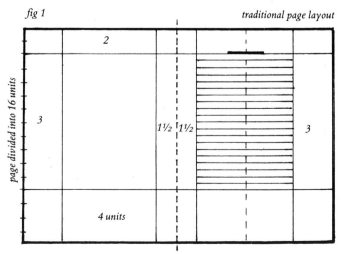

fig 1 *traditional page layout*

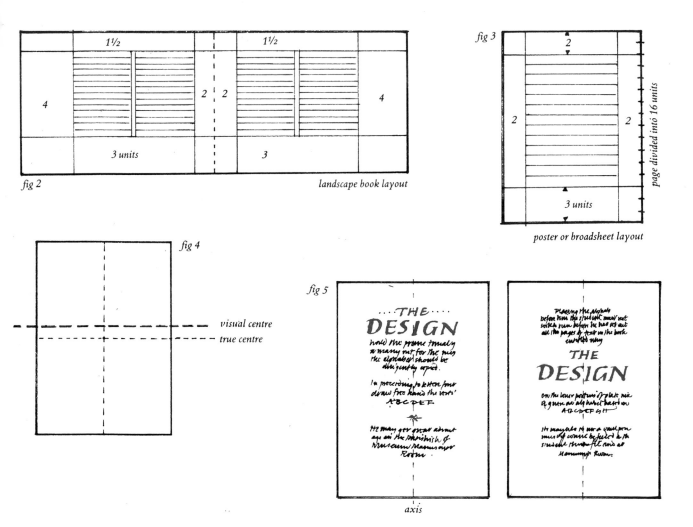

fig 2

1½ 1½

4 2 | 2 4

3 units 3

landscape book layout

fig 3

2

2 2

3 units

page divided into 16 units

poster or broadsheet layout

fig 4

visual centre
true centre

fig 5

THE
DESIGN

axis

Margins for a landscape book Use the same principles as for the traditional page layout but imagine the vertical or portrait page turned on its side. Now the centre margin becomes the head, the fore-edge the tail and so on, see Fig 2.

The same principles can be applied to formal panels, broadsheets and posters, see Fig 3. Formality, informality and the nature of visual communication will play a part in the choice of layout. Generally, the top and visual centre are the most effective positions for important elements, see Fig 4.

Thinking about contrast in layout

When organising a design, think 'visually' with small thumb-nail sketches, see Fig 5. Begin to group the elements into blocks to make shapes of texture and free space. Decide and select which are the most important and emphasize them by size, weight and colour.

Make contrasts to break the monotony of the text and create visual impact. Perhaps you can surround the blocks of text with more space. Play about with their shape and the shape left or created around them. Can you make these more interesting? Are they in the best position – too high, too low? Be aware of recommendations like margin size and the visual centre. Rules may be broken, but they can help when in doubt.

Posters and notices Make sure that you are conveying the essential information, e.g. event, date, time and venue, clearly and quickly. Use bright colours to attract attention. Research has shown that red lettering on white is one of the most legible and also the most easily remembered. Avoid using too many different letter sizes or letterforms. Consider using magazine illustrations to complement and reinforce your message, e.g. a coffee jug for a coffee morning poster. Strengthen the outline of the illustration to give a strong clear silhouette.

Symmetrical layouts

These are most suitable for formal occasions. The visual elements are carefully balanced around the vertical axis and line length becomes critical.

The text will need to be organised into similar line lengths. Count the letters and word spaces, and try to arrange them to give blocks of text with a simple overall shape. Having carefully written out the text, this can be transferred to the finished design. Line lengths can be measured with a strip of paper which can be folded in half to find the centre. Centring names on certificates may be done in the same way. When you are tense, variations in line lengths may occur in the finished design. These can be adjusted with a flourish extended from the last letter.

fold　　　　　*mark of line or word length*

variations in line length may be adjusted with a flourish

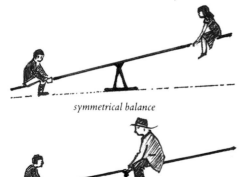

symmetrical balance

asymmetrical balance

Asymmetrical layouts

Two approaches may be explored:

1. An intuitive layout, giving a sense of freedom and movement.

2. A more structured, predetermined layout using a grid.

Both depend on your natural sense of balance used in a visual way.

A small child may balance a large adult on a see-saw. So, in an asymmetrical layout, a small element or area of colour may visually balance a large area of text or white space. When designing in this way it is even more important to try different layouts. Try cutting up the elements and rearranging them in different ways. If these are stuck down with a rubber solution, then the finished design is called a paste-up. This paste-up may be photocopied or used as a design for print, as well as providing a clear guide for ruling up the finished piece of calligraphy. Make thumb-nail sketches of magazine layouts to gain ideas and explore design possibilities.

Colour energy

Colour has a natural force or energy. The brighter, warmer colours are vibrant and appear to advance, the darker, cooler colours seem to be quieter and retreat. Some shout their presence, others whisper.

A small amount of bright colour will lift a whole page of print. Colour will constantly draw attention back to itself as the viewer explores the design surface. So the position of a colour is critical if the design and all its associated elements are not to be unbalanced. Something of comparative unimportance treated in colour may take precedence over the more important elements.

Consider carefully how and where you place strong colours. Allow their energy to feature at the beginning and end, or sparkle in small bursts over the design. It is vitally important to be able to mix and move the colour around before coming to a final conclusion. Try your colour on a good quality tracing paper to test its position. As in asymmetrical design, gravity seems to be a good analogy. A small amount of bright colour will balance larger areas of quieter tones. Darker, heavier colours are often better at the base of a design unless the whole is dark.

Colour attracts the eye immediately. The simple diagrams below help to illustrate how the eye seems to travel around a layout linking like colours with like. It is a visual game that we all play quite unconsciously when we look at any visual art-form. So use colour to unify or pull together your calligraphic layouts. Finally, when mounting and framing, select a mount and frame which pick up one of the colours in the design.

A single colour initial indicates the commencement of the black text and balances it.

A free brush form brings focus and structure to a radiating or exploding design.

Traditional indented capitals in two colours balance the varying poetic line lengths.

A formal or ceremonial layout in which the colour is governed by the heraldic device and red seal. The blue ribbon supports the whole at the bottom of the scroll as well as being a means of tying the scroll.

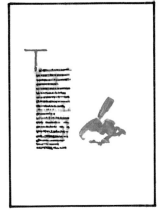

An asymmetrical text balanced by a free brush form whose colour is echoed in the initial.

Using colour in calligraphy

Who can resist colour? Although some traditional approaches demand the use of black ink, the calligrapher generally has the freedom and the means to use colour. Colour makes calligraphy immediately attractive even before the message is read. It makes communication much more effective and memorable, and its expressive nature can be used to complement the meaning of the text. In some cases, the subject matter may suggest the colour required.

Simple examples

MERRY CHRISTMAS

A formal arrangement using Foundational hand, with the holly providing a contrast of line, weight and colour. The seasonal and cultural influences demand the use of red and green.

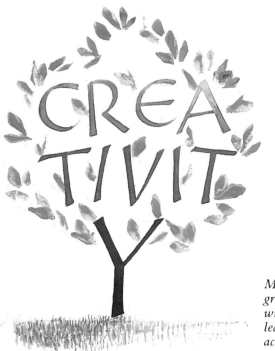

Modernised Versals freely drawn to give an image of growth. The colour change was created by feeding the nib with different colours. Rather than drawing and painting the leaves, an eraser was cut like a leaf to create a stamp. The action of stamping the colour gave a texture which adds to the spontaneity of the design.

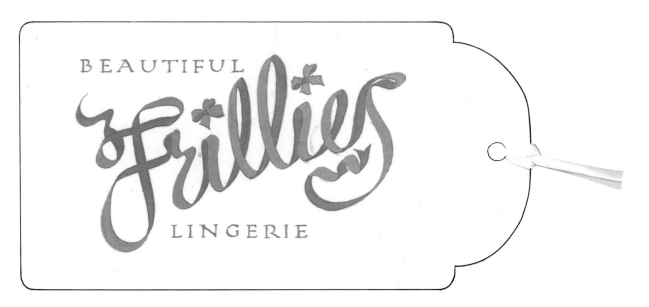

BEAUTIFUL

Frillies

LINGERIE

An idea for a designer label for luxury underwear. This was created using two pencils and was painted in warm tints to suggest femininity.

A single colour design evoking the feeling of the blue sea.

H.M.S. VICTORY

The Flagship of Admiral Lord Nelson

The Twenty Third Psalm, transcribed for Seafarers.

The Lord is my Pilot; I shall not drift.
He lighteth me across the dark waters;
He steereth me in the deep channels.
He keepeth my log;
He guideth me by the star of holiness
 for His name's sake.
Yea, though I sail mid the thunders
 and tempests of life
I shall dread no danger, for Thou art
 near me.
Thy love and Thy care they shelter me.
Thou preparest a harbour before me in
 the homeland of eternity.
Thou anointest the waves with oil, my
 ship rideth calmly.
Surely sunlight and starlight shall
 favour me on the voyage I take;
And I will rest in the port of my God
 for ever.

Greetings from Portsmouth and Southsea.

Using a limited palette

It can be advantageous to limit or reduce the number of colours that you use in a design. To extend my experience, I selected six naturally occurring earth colours and, by mixing them together and with black and white, began to explore their potential.

This exercise might be extended to a colour selection of your own choice, as it anticipates and reveals many of the possibilities of handling colour in more formal work. It may inspire interesting ideas in their own right and, to some, have as much to do with painting as calligraphy.

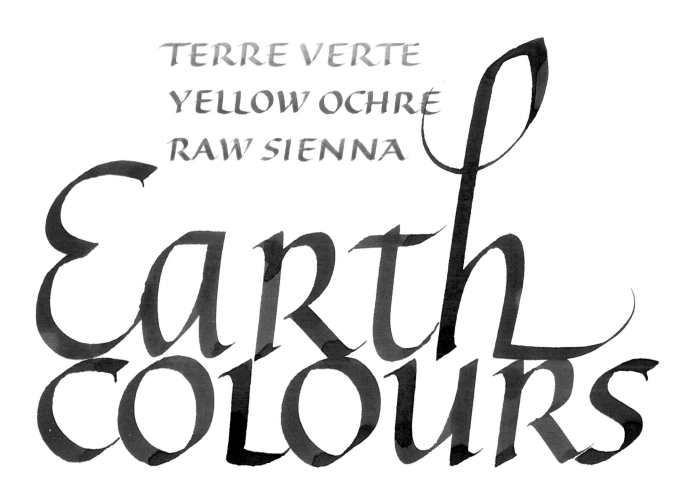

This explores the brown/green/yellow earth colours and asymmetrical design. 'Earth colours' was written in transparent ink and the colour names, e.g. terre verte and yellow ochre, were written in watercolour.

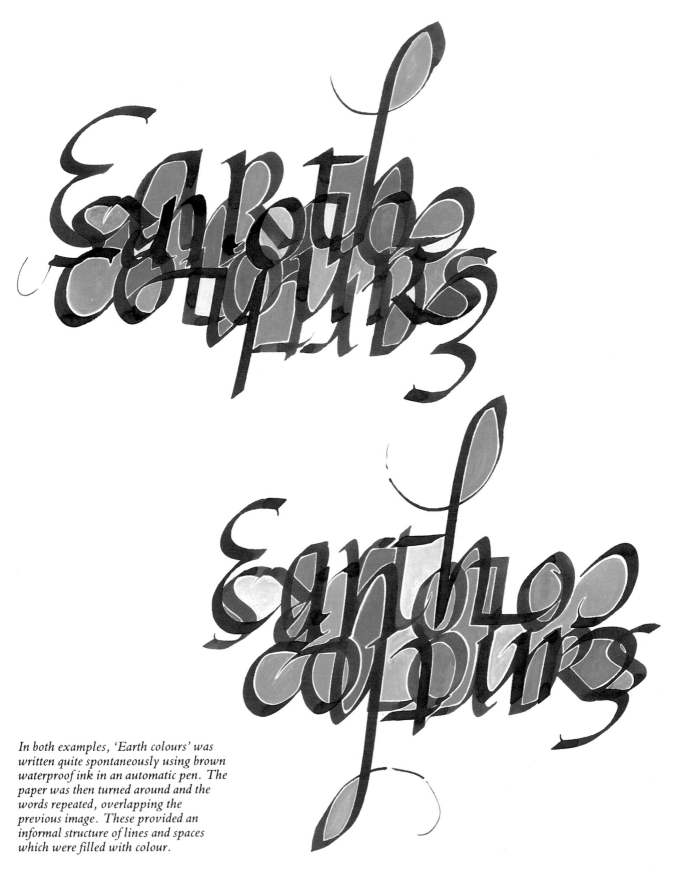

In both examples, 'Earth colours' was written quite spontaneously using brown waterproof ink in an automatic pen. The paper was then turned around and the words repeated, overlapping the previous image. These provided an informal structure of lines and spaces which were filled with colour.

Coloured paper

Coloured papers provide a source of instant attractive colour. Without the stark contrast of black on white, writing on coloured paper seems to enhance and flatter the finished result.

As well as a background, coloured papers also provide a source of cut and even-torn letters and shapes. Try cutting the letters directly with scissors or a sharp knife, without pre-drawing them. The family of letters will be most acceptable and also enable you to use the counters and remaining shapes to explore the design process. They may be moved around to explore different compositions – adding and subtracting the shapes as you divide up and create new arrangements of space. Use a rubber solution rather than a water-based adhesive to stick them down. The water content in the latter causes paper to stretch and curl. Possible papers include:

1. Cartridge and cover papers for strongest hues.

2. Ingres and other mould-mades for quieter, natural colours and texture.

3. Stationery for tints.

4. Tissue papers for translucent effects; try tearing them and exploit the resulting soft edge.

Coloured paper and white gouache combined with Modernised Versals and an asymmetric design. The centre or counter of each O provides a focus for a snow flake. Sometimes the distribution of such letters can add interest to a design – it all depends on the words!

Borders

A border holds the image on the page as well as supplying colour and added richness. A simple line seems to invite the eye to move along it. It seems to have energy and implied movement. A linear arrangement of related shapes or decoration has a similar effect. A single line or linear decoration across the width of a piece of calligraphy or print helps to consolidate the various elements and strengthens it. A border which runs around the four sides encloses the image and provides a setting, almost like looking through a window.

The border should be subservient to the design and complement it in some way. Selecting a colour element or motif from the main design is a good starting point. Late mediaeval and Renaissance borders, with their colour and realistic representational flowers, tended to overwhelm the text, e.g. as in the Hastings Hours, a fifteenth century Flemish Book of Hours. It is fair to say that much modern work does not require full borders because they seem to restrict the natural energy of the design. Also, modernism has found decoration superfluous, but post-modernist thought is now encouraging a taste for detail, as can be seen in architecture.

Play with borders by way of pen practice, and explore period work as a source of inspiration.

Playing with lines and shapes.

Simple pen strokes combined.

To create interest, think about variations of thickness and space between lines.

Pen forms, filled with colour using a brush.

Drawn pen forms which reflect the character of the nib.

Historical examples

As well as Western historical examples, explore other cultures for inspiration. Ask the questions, 'Why do I find these attractive? Why do they work as design?' You are then closer to adapting the elements and colours and creating an effective vocabulary of your own.

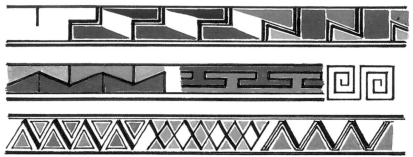

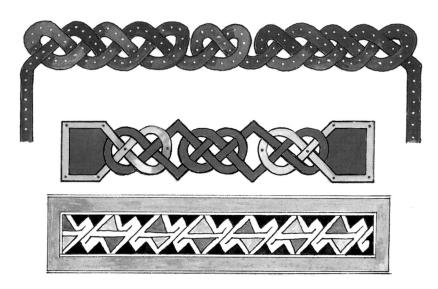

CLASSICAL ORNAMENT
Greek and Roman ornaments which explore forms of geometric space filling.

CELTIC ORNAMENT
The Celts liked using line or linear decoration with interwoven patterns.

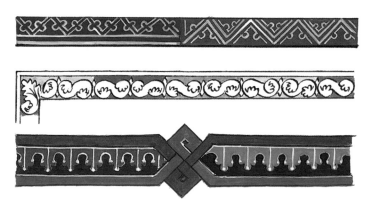

MEDIAEVAL ORNAMENT
To soften the impact of the pure hue, a line or dot decoration in white was often painted over the top.

A formal, symmetrical design in pink and grey green with gold dots. The colours are based on a dianthus or garden pink. The lines, writing and pen garland are used as borders to hold the delicate monogram.

A presentation folder designed to take a gift cheque. The letterform is based on a handwritten form, slowed down by the use of a wide brush. The ribbon tie creates a formal border and imparts a unique richness of colour.

Resist techniques

Interesting and original results can be obtained through the use of resist or masking fluid. Masking fluid can be used in a pen or a brush and is capable of quite fine lines.

The loom of time

This anonymous poem lends itself to personal visual interpretation. The imagery of the loom, with its threads, is expressed by the horizontal and vertical lines of writing. The letterform is deliberately free and spontaneous, and seeks to draw upon the energy found in handwriting. The informal capitals express the more measured and formal behaviour of adult life. They slow the reader down to consider the sentiments of the author, whilst also changing the visual texture. The free application and choice of colour reflects the seemingly fortuitous nature of life with its darker and lighter elements but which the poet believes are all part of a greater design.

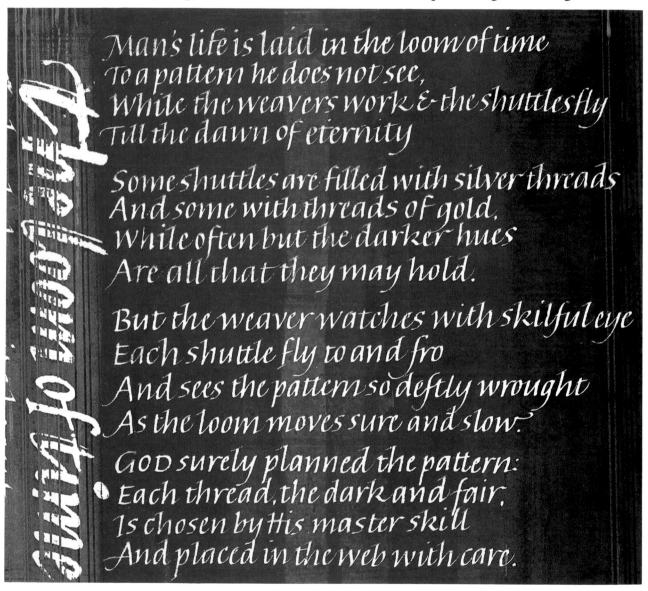

Man's life is laid in the loom of time
To a pattern he does not see,
While the weavers work & the shuttles fly
Till the dawn of eternity

Some shuttles are filled with silver threads
And some with threads of gold,
While often but the darker hues
Are all that they may hold.

But the weaver watches with skilful eye
Each shuttle fly to and fro
And sees the pattern so deftly wrought
As the loom moves sure and slow.

GOD surely planned the pattern:
Each thread, the dark and fair,
Is chosen by His master skill
And placed in the web with care.

Coloured waterproof inks, including gold, silver and black, were used over resist. The resist lettering was written with a pen, using a brush for the title.

Man's life is laid in the loom of time
To a pattern he does not see,
While the weavers work & the shuttles fly
Till the dawn of eternity.

Some shuttles are filled with silver threads
And some with threads of gold,
While often but the darker hues
Are all that they may hold.

But the weaver watches with skilful eye
Each shuttle fly to and fro
And sees the pattern so deftly wrought
As the loom moves sure and slow.

God surely planned the pattern:
Each thread, the dark and fair,
Is chosen by his master skill
And placed in the web with care.

The loom of time

God only knows its beauty ——
And guides the shuttles which hold
The threads so unattractive
As well as the threads of gold

NOT · TILL · EACH · LOOM · IS · SILENT,
AND · THE · SHUTTLES · CEASE · TO · FLY,
SHALL · GOD · REVEAL · THE · PATTERN,
AND · EXPLAIN · THE · REASON · WHY,
THE · DARK · THREADS ·
· WERE · AS · NEEDFUL
IN · THE · WEAVERS · SKILFUL · HAND ·
AS · THE · THREADS · OF · GOLD & SILVER
FOR · THE · PATTERN · WHICH · HE · PLANNED.

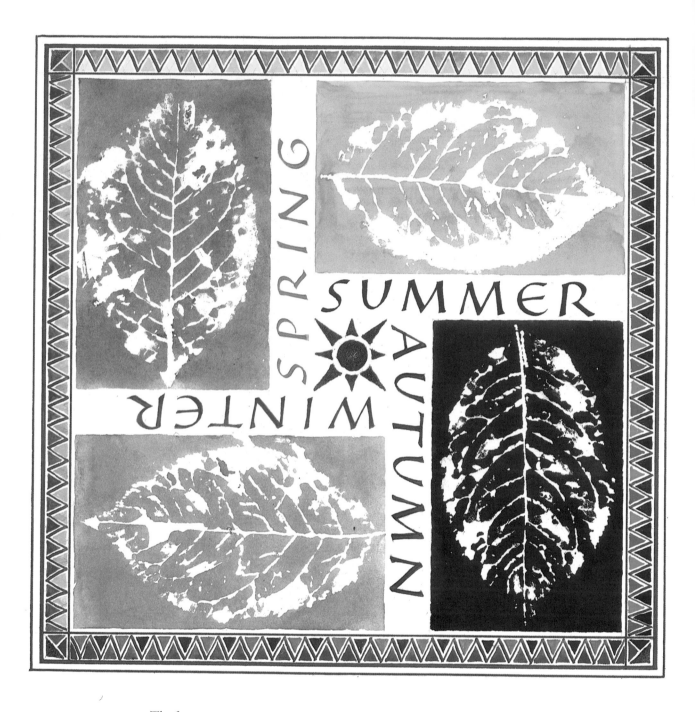

The four seasons are represented by prints of beech leaves. The veined under-side of the leaf was painted with resist and pressed down. The resulting texture was painted with colour when the resist had dried. The resist was rubbed away as soon as the colour had dried, revealing the paper which had been protected.

The coloured lettering was done with a pen and the coloured border was designed to relate to the colour of the seasons. The corners of the design and the star motif at the centre were worked in 22 ct gold leaf and gloss acrylic medium. (See pages 11–12 for details on this technique of gilding.)

Developing an idea

Being creative is never easy. The pressures and constraints of a commission galvanize us in a way that complete freedom of choice does not. We can feel so strongly about personal or expressive matter that it is easier not to start, so allowing us to enjoy the inner vision rather than live with the reality of the finished form. Yet, that point of departure or impulse must be compelling enough to get us started on something that may take days, weeks or even years to reach realisation. As with other forms of creative expression, it may be a theme to which we will return again and again. I think that it is useful to keep a notebook of ideas which appeal.

As usual, I started with a pencil sketch. I came across some lines from Hamlet (Act 1, Scene 1) and found the guards' conversation before the appearance of the ghost of Hamlet's father intriguing. It gave me an insight into the thought or myths of the period and confounded my association of cocks crowing with Easter and Peter's denial. So, I entitled the lines 'Cock crow at Christmas' as if they were complete in themselves and not part of a conversation. The pencil sketch expresses this with an attempt to link the title and smaller text visually by means of the bird's tail.

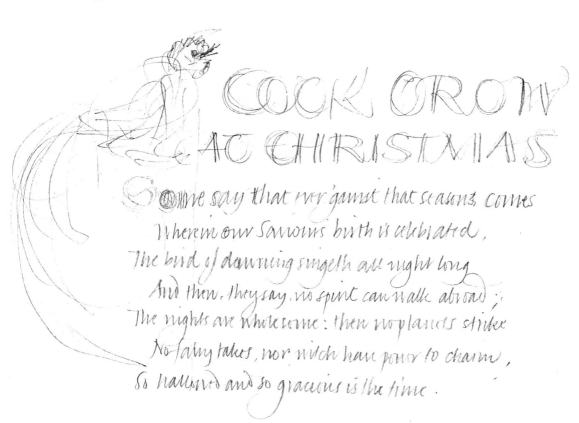

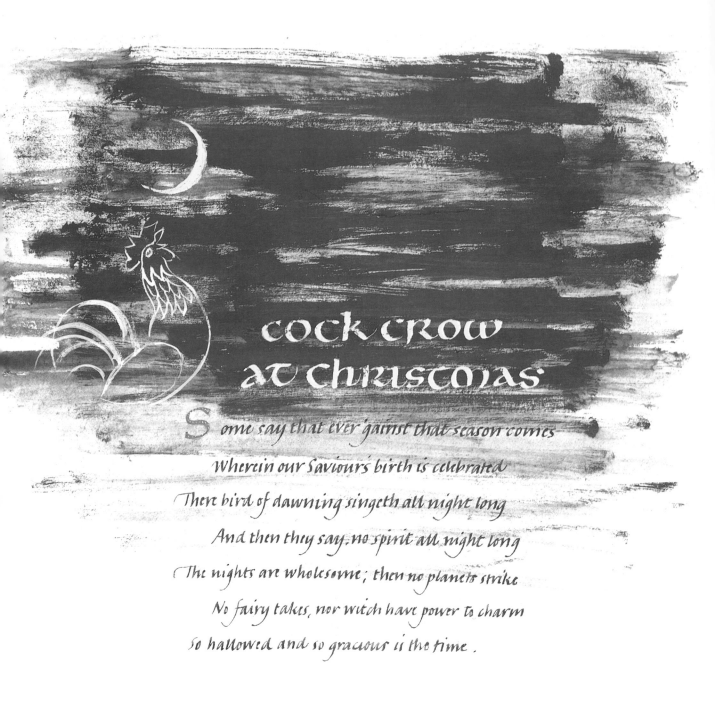

COCK CROW AT CHRISTMAS

Some say that ever 'gainst that season comes

Wherein our Saviour's birth is celebrated

There bird of dawning singeth all night long

And then they say, no spirit all night long

The nights are wholesome; then no planets strike

No fairy takes, nor witch have power to charm

So hallowed and so gracious is the time.

The next stage was to play with possible approaches in terms of colour, nib size and style of representation. Was this to be a realistic cockerel treated in line or in full colour? Did I need a reference to get the detail right? The letter shapes were chosen for their contrast of weight and form. At this stage, I thought it fun to play with the possibility of resist, to contrast the formality of the small writing with the 'not quite in control' or spontaneity of watercolour. Uncial was chunky enough to allow me to try this. The smaller text was written in brown over blue gouache which I lightened to allow the text to show. The moon was coloured cream to represent gold. I would emphasize the words fun and play to encourage an open approach. It is a kind of messing about in order to discover new things before accepting tried and tested answers. You can feel at risk at this point.

46

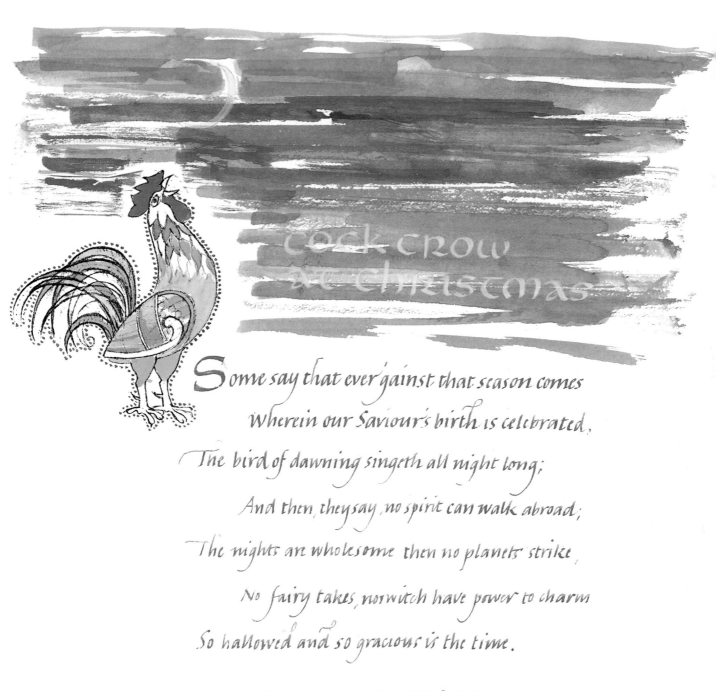

COCK CROW
AT CHRISTMAS

Some say that ever'gainst that season comes

Wherein our Saviour's birth is celebrated,

The bird of dawning singeth all night long;

And then, they say, no spirit can walk abroad;

The nights are wholesome then no planets strike,

No fairy takes, nor witch have power to charm

So hallowed and so gracious is the time.

H·A·M·L·E·T W. SHAKESPEARE

Thinking about the treatment of the cockerel, I began to wonder how the Celtic monks would have done it. I was amazed to find how many animals and birds there were in a reproduction Book of Kells and changed the resist idea almost immediately. I began to make different sized drawings and colour notes, cut them out and tried them on the roughs that I had. This is where working on detail paper allows you to overlay previous ideas and see what effect the changes will have. Quality tracing paper, being more translucent, is even better but is not as good to write on.

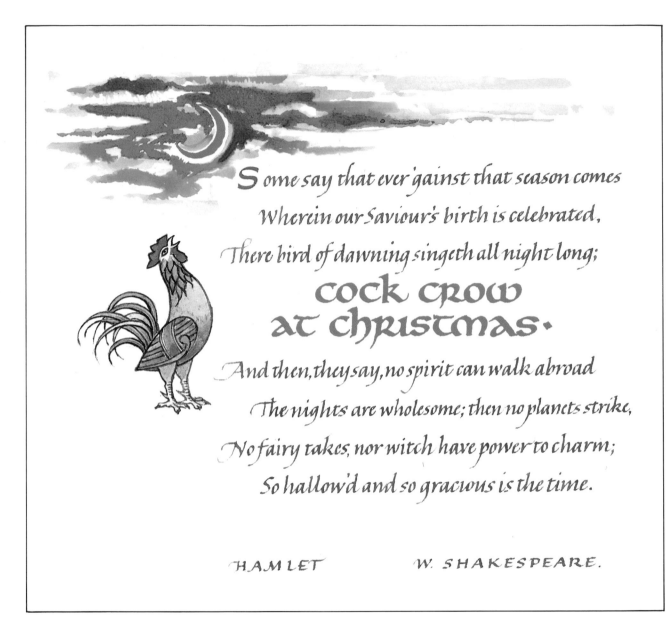

Some say that ever 'gainst that season comes

Wherein our Saviour's birth is celebrated,

There bird of dawning singeth all night long;

cock crow
at christmas.

And then, they say, no spirit can walk abroad

The nights are wholesome; then no planets strike,

No fairy takes, nor witch have power to charm;

So hallow'd and so gracious is the time.

HAMLET W. SHAKESPEARE.

I now became aware that the design seemed to fall into two equal parts, text and sky. So, to give a contrast of shape and area, I split the text with the title, which was now confirmed to be gold and linked to the sky visually by means of a gold moon. The cockerel became smaller and the sky much less in area, but by being darker in tone it still played a significant role. Hopefully, I had retained some of the spontaneity of watercolour in the sky to contrast with the more restrained treatment of the cock. In this design some of my play experience has come through, even though the finished result is more conventional than I had imagined at first.